COSMIC COLLECT CALL

Appreciate the Mystery; Poems about Life

Renuka Susan O'Connell

IW
Press

Cosmic Collect Call

First Published in Great Britain in collaboration with IW Press Ltd

Cover art and interior artwork by Renuka O'Connell
https://renuartist.com

Cover design by 1981D
Interior design by Chapter One Book Production

A catalogue record of this book is available from the British Library.

ISBN-13: 978-1-916701-06-9 (Paperback)
ISBN-13: 978-1-916701-07-6 (e-book)
ISBN-13: 978-1-916701-08-3 (Hardcover)

IW Press Ltd
62-64 Market Street
Ashby-de-la-Zouch
LE65 1AN
England

https://www.iliffe-wood.co.uk/

For Michael
My family, past and present,
especially Grandma Loretta, with love.

Praise for Cosmic Collect Call

Delicate, surreal, wrenching, powerful, deep, poignant, tart, tasty, provocative… *Cosmic Collect Call; Poems about Life*, is a palette of many shades. Renuka Susan O'Connell captures the depth and width of our shared human experience and holds it still with skilful poetic artistry so we can appreciate it, be moved by it, embrace it and be enlightened by it. If you liked Ann Morrow Lindberg's *Gift from the Sea*, you'll love this book for its feminine wisdom, exquisite creativity and compelling invitation to a contemplative space.

Linda Sandel Pettit, Maxy Award Winning and
Best-Selling Author of *Leaning into Curves*

The intimacy and at times urgency of these poems will keep you enthralled with every page. Renuka Susan O'Connell's poems are direct, personally reflective, and at times fierce. Through her mastery of language, brilliant use of metaphor, and ability to capture the nuance of ordinary life, she weaves love and loss onto the page and into the heart of the reader. There is wisdom in her poetry and a delicacy as she unwraps a human's journey. The poems in this collection have threads of Billy Collins and at times Mary Oliver. They are little morsels that will catch your heart.

Jules Swales, Method Writing Teacher and
Author of *I want a Stonehenge Life* and
Declarative, 33 Statements that Changed my Life

As indicated in the title of its first piece, *Everything's Taken Care of: My Mother Died on My Wedding Day,* this is a collection of intriguing and deeply personal reflections across the life span of a fully lived life. The poems glitter like slivers of silver in moonlight, inviting us in, granting us glimpses into the moments we don't often reveal to one another, and leaving us, with each entry, only

wanting to hear more. I loved hearing the voice of a mature artist and woman, reckoning with what has come before, and with what she is still facing, In the titled piece, *Cosmic Collect Call*, the poet and her mother parry ways they have hurt one another, ending each with, *I love you*, but rather than stopping there, she closes with a question that leaves the reader thinking. I've gone back and re-read to find other layers and just found the spot-on image of a "ferry, dragging its wet skirt in a wake." A beautiful collection, like brush strokes in a painting that assembled together "hold" the mystery of one human's search to make meaning.

<div align="right">

Maureen Callahan Smith, author, *Grace Street: A Sister's Memoir of Grief & Gratitude*, Gray Dove Press

</div>

I want to hold onto this feeling. I want to stay in the space that these thirty poems opened up in me. I am under their spell. Renuka Susan O'Connell's book of poems opens an inner door, and invites us in. She paints the moments of her life, her cosmic life with a full palette of colors and it's entrancing. She tells us, "I have understood that one single word can contain a spirit, like a fledgling in hand." Yes! The spirits of her words work on me. She writes "creativity is not limited to paint and clay." Indeed! This slim volume of poetry will transport you. I loved this book.

<div align="right">

Susanna Liller, Author, Founder of The School for Real-Life Heroines

</div>

The poems in Renuka Susan O'Connell's *Cosmic Collect Call* are filled with the freshness, surprise, and oddness of being human. This bursting-with-life collection is wise, quizzical, and reminds us to notice, to be curious, to lament, to open wide our hearts to all we love, and to appreciate the mystery of all we don't know. Fill your soul!

<div align="right">

Eleanor Morse, author of *White Dog Fell from the Sky* and *An Unexpected Forest*, Independent Publisher's Gold Medalist Award and Winner of Best Published Fiction by the Maine writers and Publishers Alliance.

</div>

Contents

A Bit of a Prelude

On July 18, 1972, I left my childhood home, my parents, and five younger brothers for an uncharted life. With bare monetary resources and no prospects of a career, I began, what I call, my Lila, which loosely translated in Sanskrit means divine play. As the lead actor I had no script. My heart wished to play me as an artist and now a writer.

This book is for those who wish to apprentice themselves to any dream whatsoever. These poems describe everyday experiences from my youth to present day. These are the ways I've walked the path through trials of grief and struggle to seek a light in a newly formed creation. It turns out that the elixirs are faith and love. Out of nothing comes something to remind us that life lived from the unknown will never fail.

ATTEMPT TO FLY

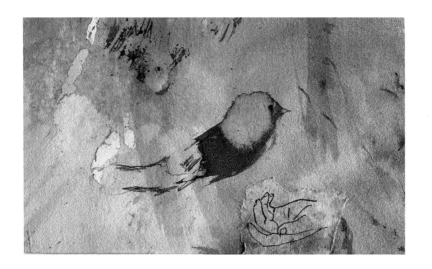

Everything's Taken Care of: My Mother Died on My Wedding Day

I was twenty when my mother died. I stood by her bedside. And peered into her face. "Goodbye Mom, I'll see you tomorrow," I said. Her small body was enfolded in an airy rose petal gown. She seemed half asleep. Her contour appeared light as a feather that would tremble in the least amount of turbulence. She was lost in the bed and found in a swaddle of pillows and blankets dented like starving mouths. Her birdlike fingers lay on top of the stack of cushions wide open as if to attempt to fly. The warm glow of afternoon sun spread its slender rays through the windows. The air was full of incense, paraffin, and flowers. A makeshift altar laid on a table with vestments draped over its sides, for a spur of the moment wedding ceremony. Just a few family members and friends tucked around her in the bedroom. A brazen gold chalice was set in the center with a white linen cloth folded over its mouth. The love seat across from the altar held a guitar and near it, an oxygen tank.

After everyone exited, I peered into her face, filled tippy top full of love's spell wearing the gown she wore on her wedding day; it was antique white, with a long V split collar made of thick satin. The back had thirty small mother of pearl buttons clipping

it into a petite bodice holding up oodles of organza that dazzled in the light. Out of the laced veil protruded a chiseled face with pouty lips and an upturned hairdo with coils of curls that framed my cheeks. I held more silken roses than I had ever seen spiraled, while off in the distance a cacophony of voices postured themselves in muted shush tones, high and low in a mono scale, as if there was a crush over the air waves. An occasional dish clanged in the kitchen downstairs, a chirp of a bird outside unannounced between the blind zone and a breath. Yet another ghostly sigh in this long, broken, symphony. "Now everything is taken care of," my mother said. For years she'd petitioned God that she live to see the day I'd marry. So odd, I thought. I felt a painful snag in my whole being. A crescendo in my body, oh, adagio played the sorrow of my heart: a duo of loss and love.

Mom's Hair

Mom faced the mirror in her French dressing room.
I stood behind her with a silver brush over her head.
Her silken strands were tangled in a nest.
She cried as she cupped the fallen hairs like fledglings.

I stood behind her with a silver brush over her head.
The doves on the window ledge squabbled in a fury.
She cried as she cupped the fallen hairs like fledglings.
The day we fed the birds in Saint Mark's square became a blur.

The doves on the window ledge squabbled in a fury.
Her almost bald head was a shock to see.
The day we fed the birds in Saint Mark's square became a blur.
In our once elegant existence.

Her almost bald head was a shock to see.
To commiserate was useless to the cancerous reflection.
Our once elegant existence.
The light fainted in shadow.

To commiserate was useless to the cancerous reflection.
Her silken strands were tangled in a nest.
The light fainted in shadow.
Mom faced the mirror in her French dressing room.
I stood behind her with a silver brush over her head.

No One Could Stop Us

We skied the afternoon down the precipices in Colorado.
Jumped moguls, kicked up powder, flew under spruce limbs.
I wrapped my poles around my spindly, birdlike wrists
and hung on. It didn't matter it was a four-hour run,
drifts, three-foot powder up to our knees, threat of ten below zero
and frostbite to assail us. We were twelve years old and flew
past scarps, fringed with evergreens and aspens, sky bound—
then earth, its boulders and carved out ice sculptures—
beneath us. For a while, we'd forget
our wooden desks covered in magic markers,
the careful placement of names we scratched into them,
the locker lined hallway where doors revealed notes, posters,
and bumper stickers, and kids with their heads down in a hush.
Whatever it was our fathers thought safe for us,
they kept in a picture frame, whatever our mothers
cursed as they sewed on buttons, matched up socks, and dusted,
lived behind us now, charged, sprung loose from routines,
pulled up by the mountain's muscles.
We were those atoms, elevated outside the laws of gravity.
No one could stop us.

No Referees

My brother leads his life in a suburb of Detroit. No one can
stop him.
A cop pulls up to the curb,
my brother shackled,
in keyless handcuffs.

Maple red, his twenty-four-seven eyes
beam through the heat.
Broad shouldered, tanned too, football jersey,
now spattered with the
blood of Christ.

I hope he lives forever.

Across the street kids play touch football.
They tug at each other's pants. Rules thrown out the window,
and whirl into a
dervish of belly laughs.

My brother left the dark forest
for a stroll across the hospital greens,
since his mind staged a war on itself
He stored his sneakers in Jesus's locker.

There is no difference between him, the clouds, or the goalpost.

In his game, there are no rules
no playing field,
no
referees.

I Prayed to See Myself

Anything could happen in our family cottage.
That box, rough-hewn rafters of pine
perched at the edge of Lake Huron,
where my brothers and I spent summers
in August. My dad played backgammon,
and lurked in the background to reprimand sons,
as he swatted flies.
At night, while I lay in bed, frozen under the woolen blanket,
I heard the water rake the loose pebbles,
horses clopped on pavement like a metronome,
while the filaments of my imagination tried on a new life.
In the morning, visitors appeared.
My cousin Jimmy rode his horse into the living room,
then yelled, *Hi Ho Silver* to all around.
Once, in early spring, a colony of bats
took shelter in the fireplace and dive bombed our heads.
I heard the neighbors say: *you never know*
what you'll see next door. They make all kinds of suds in the lake.
But who was I in all this, at days end?
The tennis balls, foolish hats, cobwebbed tables, all left behind.
Darkness ended play, but dreamtime felt elusive.
I watched as they clinked shiny cocktail glasses together,
and wondered if I would be conspicuous, should I put away
a pint of whiskey.

A Mythical Moment

I miss parts of my fertile life; the lightness I used to feel in my body; the joy that drenched every cell. It bypassed the ruins of myself. The ones built on a foundation of wonder until they were bulldozed. Trust was what I used when I was young. It showed up right in front of my eyes. "I'm going for a walk" I said. I had my favorite destination in mind. It was called "Anne's Tablet" on Mackinac Island, Michigan. I stood half tall to the verdigris bronze plaque. A nectarine glimmered, as it laid on the dirt. My girl scout shirt ruffled in the spruce filled breeze, while the sun illuminated the raised letters. What struck me was Constance Fenimore Woolson's portrait that showed her in a billowed skirt, as she cupped the needles of a pine branch. I imagined that nature could be my good genius. A ferryboat moaned and trumpeted in the distance. My sense of time blended within the undertones of people, machinery, and the clop of horses strapped to wagons that lined the docks. "She spoke to the trees," I said to accept her words. And being the native American wannabe, I told myself to tread soft on the path home.

Lilac Tree

Hey Dad,
I haven't called on you lately,
since you died years ago.
Tonight I call because, are you aware
the oldest lilac tree in Michigan belonged
to you? I thought you'd like to know.

Well,
its bones took sick and became frayed and worn out
and a fifty mile an hour gust brought
her to her knees.

The people in the town, they came
to see the old lady at rest, her
twisted wrists sunken thick into the sidewalk's
shadow.

They walked away, the air grew
larger, and the scent disappeared.
Your son Steve gathered her splinters
to keep, to make, to give.

I suspect your sorrow floats in the moon's ether and
cannot be fathomed on earth.
Somewhere I believe you smile, since you don't worry.
You told me not to,
never, never, never,
not even for a lilac tree.

Cosmic Collect Call

I drew the gossamer curtains halfway open. On the wall, next to me, was a cradled cherry red telephone. *Kring* the phone chimed with a vibration like Tibetan bells, so I was curious and picked up. *Boy have you changed*, she said. *Mom it's been fifty-two years, my god*, I said. I recognized her voice right away. She started to snort in her laugh. She commenced to play Pink Champagne on her baby grand. This time she didn't stop halfway like she used to. I remembered her frequent comments like, *You have a sanguine personality* because she liked to apply her child psychology, her major, and never pursued.

Did I fail you? she said. *Well,* I hesitated. *I know it sounds immature,* I said, *but you sent me to pre-preschool because I tried to make cake when I was three. You washed my mouth out with soap because I said shit, and you always wanted me to mother my brothers. The six of us kids must have thrown a monkey wrench into your life of gags, dances, and convertible rides. You were a free spirit that became caged. I love you,* I said.

Well, how's about you? I said. *Did I cause you to feel pain? Oh yes, sure,* she said. *You wouldn't come out to society, to become a debutant. You hardly confided in me. Then you ran off and married a musician when you were too young. I adore you,* she said. *And I hope you recall when you would have been delighted to have just a sliver of your life as it is now. And one last question,* she said. *How come you never cried at my funeral?*

HOPE IGNITED

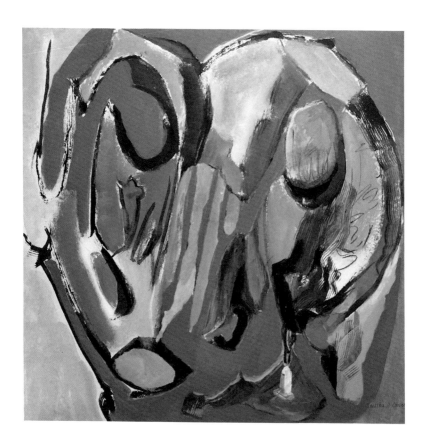

One Word

I'm full of love because it's everywhere. I can't avoid it. It's in the smile of the stranger's face who says, "Good morning," or the Barista who remembers my name.

When I felt deflated the other day, I received a text from my friend that started out, *Dear Beloved*.

A sea change happened inside my heart as if it had flooded.

I have forgotten the potency of small gestures.

I have thought of these things as slight, maybe even trivial, as in "How are you?"

I have understood that one single word can contain a spirit, like a fledgling in hand.

I'll release the kind of words that will hover over two dimensions; watch them rise, their lustrous flares overhead.

A Place for Joni Mitchell

I saved a place for you Joni,
but you never arrived,
never emailed. That's alright.
I never believed you would.
You were missed somewhere in the sea change Sixties
and I was thirsty.
I thought this would be super cool to sit with you,
and nosh on an angel's wing, an opera, or a
croquette.
I wanted to look across the table and watch you break open
the foamy heart on your cappuccino, until your face showed
inside the robin shell cup,
and watch the steam cloud the air between us.
It was nice, your Joppa necklace.
Fingers under my chin, to speak
merengue into your moon-glossed lips
disappointed
since Ruth Ginsburg died.
At least I get to allow all those bad boy drummers
under my skin, not yours.
Joni, my fear is, I won't be relevant;
so please could we agree the state of
California is covered with wildflowers?

We could ladle fresh water from the shores of
every Great Lake to bless it.
And together skate across Alberta's back and
compose a song about that.
I'd love anything to do with you,
and your penchant to cling like fire to fuel,
to fly towards the triangle of heaven,
to curse silhouettes beneath streetlights.
I waited for you at the French restaurant, Joni,
where scalloped plates on the walls vowed never to
be broken.
All I've eaten in the last two weeks is
slick with cream and high on yeast, a sure way
to commit suicide.
The menu here is laced with amber concoctions that
resemble resin amulets like notes in your songs.
Joni, you're with me,
yet you're not.
Your music is from space
where women slit peaches and drink men;
so sweet, bitter, tart.
I can't even think about food anymore.
I've already started to mourn you.

Uncertain Karma

"You got bad luck," Robin, my then workmate said. It was fifty years ago. We were in her steel gray Toyota with the side door bashed in. A pair of cushioned dice hung from her rearview mirror and a Dunkin' Donuts bag lay crushed on the floor, under my foot, along with a black thumb tack. She wore a t-shirt with sleeves rolled to expose a tattoo of the Star of David inked into her fawn skin. A towel with Bug's Bunny characters printed over it, wrapped around her torso like a mummy. One of the few items of clothing I owned were a pair of cutoff jeans and a rose halter top, since every possession we owned had been stolen from our trailer. The sun dodged the visors and attacked our eyes. And it didn't help, that the AC chugged along and spewed fumes of charred remains. "You probably have some karma to work off," she said. "I can't figure out what it is right now," I said.

Some People like Center Stage, I like being a Proton. An ode to Julian of Norwich

All will be well, and all will be well, and all manner of things shall be well. Yep, no matter what happens, this is the truth I've gotta believe it or I'll go haywire, off the skids and back again. Hell, I know there's no guarantees and nothings for free, but Julian said it, *All will be well.* I'll hang my hat on that, cuz I don't know much else. This fuzz, fir-ball, pinprick of me rolls like a galactic chess piece inside the whorl of the Universe. I'm queasy with tension, ya know, cuz all I do is flail in space inside a lotto crank cage. My proton meets a carbon, and we boogie until I crack into a quark. That's when I struggle to see myself. So faint, flat, dashed, flunked, upside the head. It goes on, ya wanna hear? I might as well lay on a microscope slide, so some geezer can enlarge me, and watch all the flotsam and jetsam squirm around like the northern lights. Yep, that's me, all those round blobs that pulsate like an atomic nebula. Yeah, and I've been dumped into test tubes, wow that's a trip, explosive by nature; what a dearth of hydrogen that whaled on my phosphorus. That's me, a fan damn mambo mix inside a beaker. Shake it up yeah. Oh my God, this is gone too far. I mean how much damage can a proton do, so all will be well?

Never Give Up

I hated to run.
Two miles seemed like an eternity, so a marathon?
First, implement Jeff Galloway's 'non-runners plan' just to finish.
ie. Don't be a fool and run twenty miles the weekend before.
Almost everyone in the meditation group signed up.
I didn't want to be a black sheep.
I'm all about mind over matter.
And I like to test the power of grace.
My last run had a goal-the donut shop.
The New York Marathon accepts anybody.
Tim, our waiter at the diner, will compete with an apple on a tray.
I hoped I wouldn't run into him.
Out of 50,000 people that ass was next to me.
He sprays when he talks.
Keep and eye out for short lines to a port o potty.
Klezmer band in Brooklyn-cool.
Who the hell plopped a wet sponge on my head?
If I was to go on, I'd live a handicapped life.
My knees told me so.
Met a guy along the way.
"Let's support each other," he said.
Why do people turn altruistic under duress?

I told him I'm not going to finish the last 6 miles.
"There's a problem," he said.
The back of your shirt says, *"Never Give Up."*
That wasn't my idea.
Take the shirt off?

F--ck it, I'll finish.

No Freedom

I have been ready for a relationship with God ever since I can remember. When I left for college, I climbed the stairs to the choir loft at St. Paul's and kneeled down to pray. *Jesus* I said, *find me a teacher who is alive.* I looked over the lacquered brown rail and focused on the tabernacle. It was gold, protected under an arch, empty as its metal, transparent as its glass. Personhood was not its portal. A basket of crisp, uniform rose-pink carnations flagged each side of the altar. *This will tell me if you exist,* I said. Melted into the vibratory alchemy of persons, past and present, three blended into one; God, Jesus, and the guru I met four years later. It is said that when the student is ready the master appears; mine did, outfitted in a kurta and a dhoti. To God we devoted our meditations, our work, our bodies. We sang his songs for Buddha, for Krishna, for our goal. There was one, final song I mouthed in front of him, one I failed to memorize, one that severed our oneness. *Look me in the eyes,* the master said, *and keep your hands folded.* We met in a grove on an August day. I was lined up in the front row, with thirty other women, next to, and behind me. Across from us were the men all dressed in a sea of white. I stood there suffocated, trapped in the six paces of space between myself and the guru, who pronounced he could take us to Jesus, God, or truth faster than anyone. So, imagine my puzzlement for what the song was about: no free will. I paced the aches of my mind and told myself

26

I must have misunderstood the meaning. The afternoon blast of sun stung my forehead and sweat that dripped onto my nose. The rayon of my six-yard sari was glued to my thighs like cellophane. It was the heat from the words he wrote, forced to look him in the eyes: *Give me no freedom,* he said. Yes, Jesus had delivered a living teacher, and I had outgrown him.

I am a Universe

I am quiet on my walks. I let go of thoughts that enrage me. I hear my rhythm if as if nature itself. I am pure at this time. I am free. I listen to the chirp of birds and stop to greet them. Sometimes I'll have a 'standoff' with one of them. We look each other straight in the eyes, like the eagle and I did, for fifteen minutes. He was still there when I walked away and returned. My well is so deep that no one could touch it. There are no words to describe who I am or how I want to be in this life, and yet I feel I am a universe, a warrior, an open seed pod with silken hairs. I am dangerous. I am a shock because I will not match other's notions of me. I have more to reveal and offer. I am a walk through the fields. I am a bird. I get caught in the snare of both innocence and shame. A bird never feels this, and I just said I am one, because I am human, I am intricate.

ALLIES

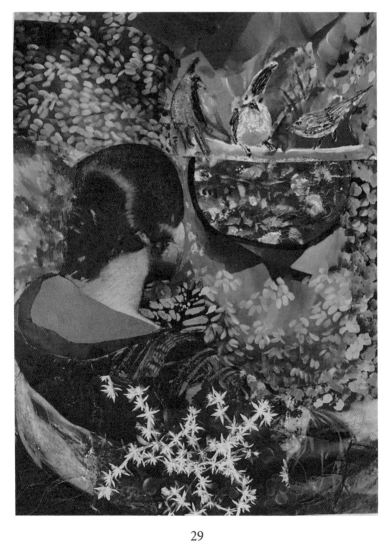

An Artist Belongs to No Country

Where are you from? he asked.
I'm from everywhere, I said.
His grin revealed he understood.
An artist belongs to no county.
I'm from everywhere, I said.
What a strange question from a Maitre d'.
An artist belongs to no county.
I'm red in the highest frequency, violet in the shortest.
What a strange question from a Maitre d'.
I've collaged paper to understand shapes of myself .
I'm red in the highest frequency, violet in the shortest.
Goodness nor dumbness know nothing of race or geography.
I've collaged paper to understand shapes of myself .
Colors I've dispersed in oil, they create rainbows.
Goodness nor dumbness know nothing of race or geography.
Creativity is not limited to paint and clay.
Colors I've dispersed in oil creates rainbows.
His grin revealed he understood.
Creativity is not limited to paint and clay.
Where are you from? He asked.

Artist Days

If you ask me
how my studio days are

I would say; I love to
walk in the room and yell, Aloha,

to follow the glimmer of a bronze chime
and clang to announce, I'm here.

And move my brush
over the numbly gesso on wood.

The curious, younger girl
in my fingers, scrapes, dribbles, pecks, the rigid surface

while the room sounds like a hum,
a constant drone left over from tamboura.

I would say I enjoy
the resurrection of life that died,

and to smear and erase
until phantoms appear from the depths.

Even the preparation shouts out to me,
canvases pulled out of their store-bought skin,

no longer vestal virgins,

hapless, they'll be drowned in a pool of magenta.
The confluence of shapes
are prime players here,

for they have conversations that range from quiet
to bright red heated ones.

And whatever lies on the surface
could be covered in a cool flax blanket.

Which is why I love this play
of innocent actors, whose desire it is for a good set design.

It all begins with the darks and the lights,
then come the temperatures, the cool and the warm bouquets

like flung open poppy eyed flowers who
wish to be painted as their adolescent selves.

And I will add more water
to their otherwise crisp petals.

I want to paint
four straight lines that will interconnect me

to the four seasons of the earth,
to the curve of the globe,

the lay lines, currents,
rip tides and seismic shelves.

One day I'll start a contour drawing
to depict a vase,

that will begin with me
when I respect every crevice,

and end with us, when the flaws are known and the glint
is reflected in your face.

This Moment

My groceries were as heavy as the day.
I wrestled them to the floor, when a coppered
penny ruby flash caught my eye. A female cardinal
pecked at the feeder outside my window.

In the near distance, soot grey trunks, pock-filled,
and leafless stood exhausted from the winter storm's
struggle, while its fingers released a cerulean life
to join the fest. Then a black
peppered mohawk drew me into
this menage.

I didn't breathe. My joints froze.
My body's rhythm
traced her wooly down.
Her ruby glass eyes lasered into mine.
Her heart pleaded to drum 90,000 more times,
this fledgling as nervous and
hungry as I.

How Much Longer He Has to Live

The unknown is pecked by songbirds on our feeder and
it lays beneath the animal tracks.
Hangs off every tree branch like woolen moss,
floats in water like a game of swans.

His gaze locks into mine fathoms deep.
Newly wedded are we?
Because now the sound of his voice and his
fresh pressed words fills space like clean sheets on a line,
though he ponders how much time he has to live.

A wild angel has appeared with a wreath in her hands.
She hovers over the threshold of our new house.

To cast a spell since the mystery we face
is a riddle.
She rushed us through our front door,
told us this was the last chance to settle differences.

Led us to use this time to grow out of
the dull voices of our duties.

Told us that our windows are portals
between ourselves and the wilderness of our imaginations.
Told us to keep them clean, shiny, like our
dreams to reinvent ourselves.

Love

There is a sudden spark in the air,
sometimes its invisible to me.
I hold memories that kindle the fire like,

the love of the whirley dandelion head
while it floats in the air,
the love of a father before he punishes his son.

The fragile look of a girl who sits on a bench
under shelves of the clouds,
the warmth of the garden far from the
clamor of the city.

The love when you kiss my neck.
The love of the fox's eyes,
The love when you greet me every morning.

The love in the quiet, this second
which I have scribed with my pen,
a love that had welled up this night

like seeds scattered through the
rich soil of being.
The love before I got up.
The satiated love now.

Flight

I heard an odd sound in the ditch beside the road.
Curious, I leaned into the ink-like water to locate
a possible amphibian.

While I gripped the steel-gauge wire to keep my balance,
it let out a boing that quivered in my hand.
When I looked up, I was eye to eye with a plump charcoal
feathered bird who wore a buttercup yellow cap
that sea-sawed in the afternoon breeze.

Now I hug my honey. I fall between his heartbeat's flutter,
nestle into his warm fleeced robe, this in between place;
this world and the next.

Round Island Lighthouse 1980

On a small island beach,
I sit with an open picnic basket,
Michael's canvas shoes kicked into the rocks.

Beyond that—seagulls in a cloud,
a ferry drags its wet skirt in a wake
and the land resembles a line of bronze tinsel.

A wood and stucco lighthouse beyond
gapped with holes full of vast sky,
the moon over a bridge.

No keeper, wife, or child,
just the mirage of a fortress over waves,
pearl white with a red door.

Its mournful horn gone silent
as if the one purpose now is to allow
actors to pretend there's a mystical force here.

A portrait remains on its wall,
tilted and cracked, to show
a once lion-hearted beacon.

The plaster weeps iron tears
from its worn-out paint,
and exhales mildew from its sides.

Some teenagers and children
carved their names in its goose bumped skin—
arrow, hearts, and forever yours—

and stared up at the lantern's thick glass,
with its teeth knocked out,
and shards of its jewels strewed around

over a stairwell that's now
exposed to the froth of the lake's air,
worn out like a neglected senior citizen.

How immediate the intimate
is revealed in a dilapidated lighthouse,
how the stony watchtower tilts under foot.

MOURNING

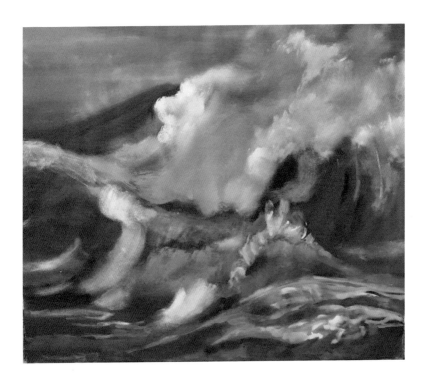

The Universe Holds My Back

I'm stuck for some reason. My clock ticks; my memory falters. Sometimes words enter through another place in my body. I'm afraid I'll lose him, my husband Michael. I make attempts to dig deeper with him to recover what's lost. The effort is in vain. I don't have any control. I'm overwrought between sadness and frustration. "How did you sleep" Michael said. His thumbs pressed my sore muscles on the side of my spine. The cuff of his fleeced robe warmed my chilled ribs, cocooned in wool. I sat with my toast and almond butter, a cappuccino in front of me. This room was never simply a dining room; because I used it as a place to travel outside its windowpane. It was the steam of the milk reflected against its newborn light that brought me present. The caw of a crow sent an impulse through my veins, loud in my mind, while I gazed at a spider caught up under the candle wick. "I slept well," I said. It was then I realized I had this ritual of love I could count on. The universe held my back, will hold it.

An Old Friend

What we knew then:

A meteorite fell to earth for the first time.
Antarctica became a continent,
no longer considered an enormous ice mass.
The moon was photographed for us to see.

This all happened 175 rings ago on the girth of the oak tree,
just slain, its trunk laid across the street.

But she wasn't even dead, I lamented.
Buzz saw man agreed, said it was sad.
The town wouldn't approve the site otherwise.

I thought about how, in one year, an acre of trees
would supply enough oxygen for eighteen people.
How patients with views of trees healed the fastest.
How their planks were used for Viking longships.

Most often, we become mirrors for one another.

I, while I chewed on my toast, and
gazed at her muscular body.
She, as she shivered water droplets from her arms.

Her root system played footsie
on the edge of the yard and
stopped, short of harm.

If she could talk, I think she would mention
the fluffle of rabbits that chased around her.
Be delighted for the ocean's salt speckled on her leaves.
Tickled to hold a new nest.

She was patient.
Gave so much more than she took.

Refuge

I won't recall when I swooped under the cafeteria table to
pad my ears against a panic-stricken siren that screamed
we'd be reduced to powder.

Won't recall skyscrapers detonated; no skin, no teeth, no nails on
5th Avenue,
Won't recall unblemished peaches in
stalls on the street,
nor carriages in Central Park, or rollerbladers there
with magenta hair.

Won't go to confessional to wait in line with
abusive priests. No Extreme Unction, no
frankincense, no tabernacles lighted.

And schools, they'll be for fish because they know to
dodge bullets.
Won't be food deserts and clerks that
say, *Oh no, we don't carry anything that grows.*
And there won't be anyone to arrest because prisons
outnumber homes.

Mattress tags will no longer say, *Under penalty
of law, this tag not to be removed.* And computers will
no longer have *help* options, because they never helped.

Fires won't destroy what they destroyed before.
Droughts will compete with floods until the
best wins.

There won't be any contest because what does
that mean, when so much has suffered.

I won't worry about ambient light blocking my telescope.
I'll face the stars in my bare earthy suit, one final time to inquire
if it's true; that we're created from them.

They will reply, because that's what relatives do,
they say, to live and play,
as if none of this
mattered.

A Certain Mystery

I feel the strum of the earth,

the jaws of climate,
rain cuts like metal sheets so sharp,
fires spew the guts of bark and sap from century old trees,
tornadoes rip houses like they're nothing more than toys.

Cell phone towers—blink their invisible pulse.
Microwaves—taste the malnutrition.
Electronic currents—disturb nervous systems.

Adrenaline makes me bolt
from car horns, alarms, and back up signals.
Adrenaline has flooded my ground,
drains my cortisol.

A billboard a story high pictured a native American.
Stop littering America, he said.
His chiseled face chestnut brown,
showed a single tear drop that bled from his eye,
his head dress an accordion of eagle feathers.
A beaded medallion glimmered in turquoise and seed shells.
Oh my God, I said.

Cast-off bags of take-out,
mounds of cigarette butts,
the odor of putrid waters,
had elicited so much sorrow.

Part of me went extinct.
Part of me cauterized my breath.
Part of me became cold and numb.
Cold and numb to pandemics on the rise.
Cold and numb to fertilizers in the lakes.
Cold and numb to possible worldwide famine.

Pipeline five is buried beneath the great lakes.
Ten thousand sequoias have died.
Plastics have become foam of the sea.

Nature reflects assurance that we are provided for.
That she'll correct herself.
It's a mystery I accept.

The End

Endings are cruel like the sheet of ink that envelops the sky.
The moment when neighbors hide from each other
to measure their weight of water, to double-check their
wood piles, to estimate the time where day and night leak
into one obsidian screen.

A black hole where my breath and eyes watch from the
canopy inside. Not one caw I've heard, the birds have fled.
This can't be permanent because hope
never vacates the premises of my mind.

I once was friends with the moon
who hung out in the backyard.
I looked to the hedgehog to
mark long winters.
I saved the seeds and fertilized them,
the creator, both tender and brutal.

Now is all that's left, what I have—an end.
The one response; to sigh
and become the truth of it. A flare of
stars that hurl across heaven out of reach.
Mist and dust fall on head and hands.

The first bang that brought forth a person
surely would not end my ancient cycle.

I Wonder

What pastel portrait I'd rather be composed in
than this one,
a woman next to a side table,
cozy inside four walls of satin lavender paint,
maple shelves full of books,
the computer off,
a pen swirled in my fingers.

It gives me pause to think
about the nest on the sill,
wildflowers sprung from the grass,
and the earth turns one more time.
Iceland, Africa, humanity thrives
under the sun.

Beyond the bedroom walls
there is not much to crave,
not a workday that would require a train to work
or a Christian Dior dress
tailored to hug each wavy curve.

No, all is right here now,
the gnarly spikes of a vintage spider plant,
a small glass amber jar, an array of pencils,

a stern wooden Chinaman at the base of the lamp,
and these three books,
kibitz together in casual conversation.

Understand me
if I close my eyes and wander
to the thinnest colorful novel, her cracked spine splayed open
while my fervor
pulsates inside my hands,
dragonflies on the stem of a plumeria,
and my spirits jet off to a sphere
painted as one vast ocean
and about a million shooting stars.

All of Me was There

I swam in the ocean, in Swampscott Mass. I pushed through the waves and raised my head to pivot round. I noticed the Boston skyline juxtaposed to my right, while my head swayed on waves. My back was weightless and the lenses in my eyes fastened themselves, to the distant brownstones and smokestacks I would call home. All of me was there.

I am One

I've come to the water's edge to notice its
moodiness. One day, its placid drops tug me
out of my thoughts. Other days, angry steeled peeks
ebb and flow into satin-like
sighs of relief.

I've come to stand and be tickled by the swirls of foam
between my toes, to hear the swoosh and crumple of rocks,
to pull the cool spiked ripples closer to my body.
One of them pounces and breaks me wide open, while another
dares to leave me aloof.

I've come here to prostrate myself, to lean towards the wind's
 edge,
to listen to the drone of the chimes behind the horizon's curtain,
 to be
awoken out of indifference by a gull's shrill call. To swim amongst
the trillions of drops and know that I am but a single one of them.

Silence

When does the silence begin and end?

Words break minutes into icy shards.

I wish for them to melt, so I'll never
have to ask this question again.

SACRED NAME OF GOD

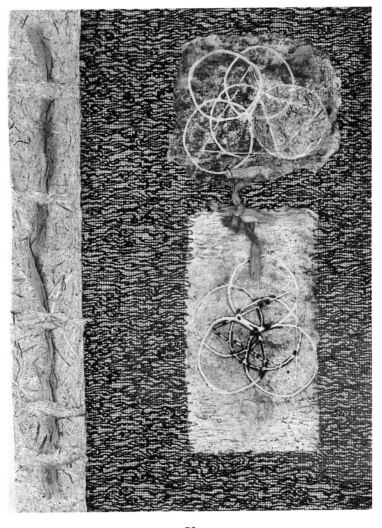

Ode to Meister Eckhart

There's a place in the soul where you've never been wounded.

So why do I spar with myself all day,
and with the shadow puppets at night?

My heart is an escarpment that begs to be scaled,
its existence is undiscovered and unnamed.

Certainty is a phantom.
The game is hide and seek.

I continue to play with thoughts that ricochet off
this hologram of earth.

There must be a place
like this, unspoiled.

I need to believe this.

Timekeeper

I am triangular and upright. Alone.
However I'm set, I click clack.
Whatever I hear, I clack on.
Steady as a drip, unperturbed by good or bad.
I am not truthful, simply reliable.
The timekeeper of a note, a measure.
Most of my days I've lived on the satin reflection of soundboards.
It is quiet, with fleeting shadows I have looked through so long.
It is part of my timbre. But time changes.
Atonal and jazz releases the pendulum's weight in me.

I am the student. A woman stands beside me.
Testing my heart for who I really am.
She turns to those tone deaf, the quartz, or the sun.
I hear her voice and mimic its grass.
She applauds me with smiles and thunderous clap of hands.
I am a daughter to her, then and now.
Each day her beat restores my stasis.
In me she has disowned an uneasy girl.
In me an older woman shouts after her
day after day, like a blue note.

What I Saw in Harpswell Maine

Waves cluster into magnetic fists.
Anvil-like clouds crowd overhead and the rest
are fairy drifters, sandwiched between aqua ribbons of whipped
vapor.

The wind
wraps round the trees like a crazed siren to
pulsate the minutes, like imposters who have overstayed their
welcome.

What I cherish most is the way my skin and hair are seduced
to compel me to believe that
this moment, I'm more than beautiful.

The Trouble With Poetry.
An Ode to Billy Collins

The trouble with poetry I've figured,
as I walked in the meadow on Thursday,
cool breezes ruffled my baby fine hair,
a flock of birds on the wires.

The trouble with poetry is
that there's an infinite urge to manifest many,
more elastic spaces inside of me,
more harvest moons
shine down upon the rivulets of thickets and springs.

Until the time actually comes
when I recognize that I'm
writing phrases with a love
I can't even begin to trust.

And there's one wild thing to do
to look out my window
and stare until a chime clangs and a word rises.

Poetry fills me with curiosity
and my mood stretches between the heavens and soft dirt.
Poetry feels like a tantrum of grief

that I confide in someone who hovers overhead.
But mostly poetry offers the
symbols to tease out my hesitant self,
to walk all day and ponder
to talk with them till my guard falls down
and grace, with faith, show up like twins.

And along with all, the urge to slash,
to break into a vault of memories
and sleuth them until the best wins.

And what a bunch of unconscious ferrets we are,
investigators and private eyes.
I listen with glee
on how to cook a chicken on a car
engine pulled over at a roadside stand.

Which isn't one of the best ones
I've ever heard.
They're the ones in coffee shops,

like the barista, who resembles Liz Gilbert,
whose chocolate, cream, and prayers blur in latte steam
and her days of too much and many.

The trouble with poetry is to make
those clumsy alterations wait their turn,
since the remainder of wish bones are separated and the
sounds of my neighbors desire to be heard.

Poem

A poem's on fire.
It sticks to my fingertips.
I flick and shake it off, off, off. Its sting
bright with blood.

It follows me like a dog wagging
its tail, and sometimes it brushes
my calf like silken fleece.

When I call it to me, it flutters in midair,
the propeller of its wings puffs wind
across my face.

At nighttime it screeches like creepers
in the distance. I imagine perhaps I'd decipher
one squeal from another.

In my dreams it shows me a box, taller than me,
transparent, filled with air, and one rose on top.

Now in the morning I lay in bed and ask,
is the gift for me?
If it is, I'd want to write it
for you.

Connect with
Renuka Susan O'Connell

Thank you for reading **Cosmic Collect Call.**

I hope you've enjoyed the book and will leave a review on your reading platform of choice, doing so helps other readers search for works about resilience, hope, grief, the divine feminine, love of the waters, gratitude for the richness of life.

To connect with Renuka please visit her website:
https://renuartist.com

Or email renu@renuartist.com

About the Author

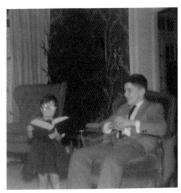

*Love at first sight. Just sayin',
I was two then...*

I've considered myself a beginner many times in my life. When I signed up to a writing class six years ago, I didn't consider myself a writer. And now here I am.

Previously, I owned an art-oriented business in Boston for thirty years. Like Lucy behind the counter in the Peanut cartoons, I listened to everyone for less than a quarter.

Born a catholic, I reinvented myself as a meditation teacher at Harvard Phillips Brooks House for a decade, and all the while, was a member of an Indian Integral Yoga group.

When I sold my business, I became a full-time artist in a community studio. I learned, for the first time in my life, how to share emotions, especially in a group of twenty. I arrived there to make authentic art and used 'play' to figure out my next steps. It led to my love of water and my concerns about the perils of the great lakes that we visited every year. As the Anishinaabe Mother Earth Water Walkers blessed each lake I documented the events through painting.

Over time my mentor moved and left me her shoes. They were navy blue clogs size 38, a perfect fit. On tenterhooks, I started to coach a group of women, ex-professionals in a range of careers. Their art rocked because their lives were rich.

In the last six years I lost my oldest and youngest brother of five. This has compelled me to live life to the brim.

Acknowledgements

I want to thank the following publications:
The Maine Arts Journal: *Art in the Time of the Pandemic, Regionalism and Origin stories*, The Chocolate Church: *Coffee Table Book*, and the anthology: *A Different Story: How Six Authors became Better Writers*.

Special thanks to my husband Michael, who encouraged me to write and has good ears.

My friend Sue Cross who recognized a spark, prompted me to study Method Writing, and has fueled my journey ever since.

Jules Swales, my beloved teacher of Method Writing, for her tireless support. Who instilled confidence every step of the way.

Maria Iliffe-Wood, my publishing partner and editor, inspired author, whose loving care and enthusiasm has made this journey one of ease.

To all my fellow Method Writers for their precious feedback and encouragement to write this book.

Alexis Rhone Fancher, editor, for her poetic skills.

Joanna Pool and Stephen Black, creatives who know how to listen.

Other Work by
Renuka Susan O'Connell

You can find stories by Renuka Susan O'Connell in *A Different Story, How Six Authors Became Better Writers.*

Printed in Great Britain
by Amazon